Things Better Than

BOOBS

BY THEODORE RASBURY

AuthorHouse™
1663 Liberty Drive, Suite 200
Bloomington, IN 47403
www.authorhouse.com
Phone: 1-800-839-8640

First published by AuthorHouse 5/5/2009

ISBN: 978-1-4389-6722-6 (sc)
ISBN: 978-1-4389-6721-9 (hc)

Printed in the United States of America
Bloomington, Indiana

This book is printed on acid-free paper.

FOREWORD

Well, my friends, the search is finally over.

I'm Theodore Rasbury, CEO and founder of the Global Search Committee (GSC) and the author of this book. Many of you already know me for my creative prowess in other areas. And for those of you who don't, prepare to be dazzled and then visit my website: TheodoreRasbury.com

Years ago my good friend Phinias and I often pondered the phenomenon behind man's unbridled and torrid love affair with boobs. So obvious yet simultaneously perplexing, it propelled me to start the GSC, a boob aficionado group comprised of two high ranking democratic US officials, two shoe shiners, four modern-day scallywags, three pantomimes, and of course Phinias.

For much of the past twelve years, our group traveled the world with one effort in mind: attempting to find things better than boobs. To accomplish this mission, my search group purposely and globally targeted the following places of interest: historical landmarks, neighbor's backyards, leading vacation destinations, Barack's trunk, celebrity hot spots, art galleries, beach bathrooms, professional sporting events, renowned museums, Grandma's basement, and many other publically desired geographies and activities. No criteria, no limitations, no exclusions, no specificities, and no rules or regulations were set forth—anything that myself, and/or leading experts in the GSC deemed better than boobs is listed in this book.

I'm greatly excited to report the following and highly anticipated information after years of research and heartache. With our verdict, I am confident that justice will be served to all of those whose heads are constantly on a swivel.

On the following pages, you'll discover our findings. Not to be mistaken:

THE FOLLOWING PAGES DEPICT THINGS BETTER THAN BOOBS.

Things Better Than BOOBS

Things Better Than BOOBS

Theodore Rasbury

Theodore Rasbury

Things Better Than BOOBS

Theodore Rasbury

Theodore Rasbury

Theodore Rasbury

Theodore Rasbury

Theodore Rasbury

Things Better Than BOOBS

Theodore Rasbury

Theodore Rasbury

Theodore Rasbury

Theodore Rasbury

.

Theodore Rasbury

.

ABOUT THE AUTHOR

At an early age Rasbury became widely recognized as the informal leader of Person's with Influence (PWI), an indigenous and sought after societal group both intimidating and selective in its recruitment of members. Practicing a form of ancient sophistry, they offered general knowledge and unspoken services in exchange for money and gifts. Sophistry was intensely popular in pre-socratic times but lost momentum until Rasbury rekindled its' fundamental principles. Dubbed as PWI's ringleader, horse whispers around town say Rasbury was Marlon Brando's inspiration for the Godfather character.

Rasbury's major money-maker came after he started I'll Eat You, Inc., a company focused on crafting personalized chocolate pops. After Rasbury split from PWI, he fell in love with a botanist named Kitten, only to have his best old x-friend Ray pilfer and marry her. But knowing Kitten's exact dimensions, and to infuriate Ray, Rasbury crafted delicous chocolate "Kitten Pops," distributing them nationally with this slogan: "Have your way with Kitten, my x-friends wife, she's delicous!" Shortly thereafter, I'll Eat You, Inc. took off like a jitterbug, creating and distributing chocolate molds for over 3,500 people daily.

On the side, Rasbury is also a free-lance writer, motivational speaker, and inventor of the rare color dunebuggy brown. He also owns the chain Nip N' Cuts, a topless barber shop that exceeds over $1 billion in annual sales. Some argue that sales of Nip N' Cuts would be greater if Rasbury didn't air-condition each location. But Rasbury sticks to his maxim: "the colder the shop, the more magical the experience." Rasbury will soon be launching another highly anticipated product, Erotic GPS: "Sexed Up Navigation for those who cum and go." Rasbury's recent case study showed that the market for a dirty-talkin' GPS is bigger than the directional voice will make you.

For more information, visit TheodoreRasbury.com.